Self-Portrait With Thorns

BY
GAIL GOEPFERT

GLASS LYRE PRESS

Copyright © 2021 Gail Goepfert
Paperback ISBN: 978-1-941783-78-8

All rights reserved: Except for the purpose of quoting brief passages for review, no part of this book may be reproduced or transmitted in any form or by any means, electronic or mechanical, including photocopying, recording, or by any information storage and retrieval system, without permission in writing from the publisher.

Design & Layout: Steven Asmussen
Cover art: Cliff Harman
Author Photo: Taylor Armstrong

Glass Lyre Press, LLC
P.O. Box 2693
Glenview, IL 60025
www.GlassLyrePress.com

Self-Portrait with Thorns

so much gratitude
to these accomplished and compassionate
body-practitioners
who have been pain-warriors with me and for me
over these past forty years

Deb Beyer

Christina Christie

Deb Callahan

Paul Skiba

Orawan Saengsuriya

Dr. Jennifer Capezio

Dr. Joel Shepperd

Contents

Truth	1
Guilty [the poet says]	2
Sugar-Cubed	3
Dear Right Leg	4
Im/pale	5
Rooted	7
In a parched time	8
The Mercy of Red	9
Beneath the Painting of the *Virgen de Dolores*	13
Iconic	14
An [Annotated] Audit of Kahlo's Self-Portraits	16
White on Canvas	18
I Confess I Am Two	19
Frida Sets Aside Reds and Greens and Blues	20
Aubade with Attention to Rib Cage	21
Dear Frida	22
Querida Frida	23
Things Riven and Relentless and Real	27
A Mind on Pain	29
You Wound Me	31
So Be It	32
In the Warehouse of My Spine	33
Titch by Titch	34
When her body stamps its foot	37
For the Cessation of Cutting	38
Blood-Letting	39

Burying the Heat	43
dear frail dark	44
Frida Kahlo Speaks to Ada Limón about Bright Dead Things	45
I want to be inside your darkest everything	46
The Pinch of Love	47
In the Absence Of	48
I Speak to Frida of More than Daisies	49

❀

Boiling It Down to Kahlo	53
In Frida's Diary, Everywhere the Eye	54
For Daughter, Unborn	55
Desperate Beauty	57
If I could lunch with Frida, I'd tell her why	59
Hunger	60

❀

Everything moves in tune with what the belly contains	63
Muscling In	64
The year of broth	65
Renunciation	66
Stack of What Made Kahlo Kahlo	67
I Design a Tattoo for Frida	69
Diseño un Tatuaje para Frida	70
Postcard from *Casa Azul,* Coyoacán, Mexico	71

Acknowledgments	73
About the Author	75

Truth

I paint	what is real—	recording	my body
myself	a deer	leaping	pierced with arrows
because I am	pigment	on canvas	shameless
so often	a fist of organs	a way to exist	my eyes
alone	my reflection	still and always	a refuge
because	swelling	luminous	my eyes divine all
I am	a revolution	embryo	open to
the subject	in portraits—	paint and pain	the vortex
I know best	mirrors	and blood-love	of indigo nights

Guilty [the poet says]

of falling in with worshippers
who would make Frida an icon,

I'm swayable when the earth splits,
drawn to her spine and flaw

and ripeness—she, an incarnation
of fresh courage. She does not veil

her image behind a scrim of muslin.
I too latch on to her painted mayhem

in undiluted color on canvas,
mingle with her idolaters.

I cape myself in the shawl of her pain
trusting that we thread the same

choker of beads. Green for good
warm light. Olive for sadness.

Blue for electricity, purity and love.
Madness and mystery in yellows.

I mesh with the grave-diggers
scrabbling in the dry rubble

of her winters and summers.
Her days, and mine, seem to unspool

like untamed thread. I persist
without her, chase comfort in this snarl—

no remorse as I try to pattern
the rough fabric of her.

Sugar-Cubed

junior high, circa 1961
 we escaped from class, snaked
out and around the gym door

 sucked Sabin's live-virus
 oral polio vaccine
delivered up on a sugar cube

too late, Frida
 demasiado tarde
 polio at six 1913

no sweet tincture for you—
 lasting effects
 a shrivelled leg
no Cinderella slipper

just a schoolyard nickname—
 Peg-leg Frida

cruelty's never sugar-coated

Dear Right Leg

I was nearly weightless—
 a plume
 a plum
 the sun
its yellow love
 barely coppered
the thin-boned arc
 of my shoulders.

Limbs are meant to be steady.

How am I to strike
 the earth in balance
 to run
 cobbled streets.

You were my pillar.

 Now I
 lumber.
Polio's
 atrophy.
 No girlish skip—
not yet even
 chrysalis.

I don't need you
 Right Leg
 to rise.

Im/pale

—The Bus, *1929*

 a blue blue
 sky
until the electric streetcar
 rammed
 the wooden bus
 / flying /

tumult screeching
 cries un-
 quelled
 the afternoon sky
 shifts to
 all charcoal-on-paper

/ flying /
 housewife's empty
 market basket
 / flying /
 black-strap pumps
 striped schoolboy cap
 / flying /
white pants
 wrench overalls
 orange-shawl

 Madonna-look
 barefoot mother
 / flying /
 baby *bebé*
 once harbored in arms
 body crumpled
 where metal
 met metal
 met bone met flesh

 met pierce met crush
 Frida's
 collarbone
 thin spine
 thin legs

5

 / flying /
 the steel
 handrail
 spikes
 her body
 / flying /
 ribs pelvis
 and her sex

Rooted

—Roots, *1943*

In her dress of fire-orange
 she leans
 into her elbow—
 the length of her
 a figure
on stark terrain.

 Here I lie. Barren.

Only her chest chamber
 open—transparent
 windowed
 and primed
 for birth.

 Her eyes: *No life in my womb.*

She nourishes
 the earth
 from the heart's cavity—

thin vessels
 of vine trail
 and fork
 into leafy
 parchment-fingers—

 My body, a sacrifice.
 My fidelity, to Mother Earth.

 Still—
 yearning—
her wristbone throbs

 can you hear?

In a parched time

my body trembles with memory
 in its den of soft tissue.

How easily the old dearness
 and loneliness spiral—
 a leathery, mildewed tang
pushing outward from an empty center.

Pain—
hollowed out by it, honeycombed with it,
pulling my body through
 flexed and writhed—
places the body never dreamed of.

Like a dark star
 somewhere in my body,
it never stops.

I go around pulling at the sky, unearthed.

The Mercy of Red

I vow to listen
to the lulling voice
in the small
comfort
of the afternoon rays—

Close your eyes.
Let the sky hold your pain.

Words cushion.
Behind the canvas
of my eyes,
tiny red crosses
stamped
on white stretchers
parade—
Red Cross
for Lilliputians.

All pain
carried off
bit by bit.

The stretchers sag
with the weight.

Open your eyes.

It is bright,
the light.
Happy.

Red and white
like apples
on starched linen.

BENEATH THE PAINTING
OF THE *VIRGEN DE DOLORES*

—My Birth, *1932*

It is I
not
my mother
who gives birth
to me, head
fully formed
thrust
from the womb
that fails me.

Blood
in vain
spoils
the white sheet
beneath me
as another
veils
my head.

My spread legs
speak of
surrender
to the Virgin of Sorrows
who crowns
my bed.

I give
birth
to myself
in oil.

Iconic

—photograph of Salma Hayek playing Frida Kahlo as she paints
Self-Portrait with a Broken Column

 her wheelchair she is in
her wheelchair palette in hand
 from her lips cigarette
 like a child's lollipop sags
she paints hair twisted up clasped
 above her neck's nape painting
 she's painting
 her wheelchaired image mirrored
dim light scarf the tint of red wine
 or dried blood snugs her neck
 curtains her chest

 she paints strapped into a corset
crisscrossing from scapula to waist
 erect in the wheelchair she paints
 defining lips eyes steel
bristled with oils a body in a human harness
 dabbed onto canvas
 onto a fissured landscape void of green hue
no pets no sign of comfort

 only paint her hair loose
on the Masonite canvas freed breasts
 bared between a transparent spine
 painted not bone
the wreckage of marble ionic column
 only a paintbrush could patch
 she rejects
 camouflage invention

 no deception for this woman
painted nails carpenter nails prick her flesh
 prick the canvas of her body

 pincushioned paint
painting in oil one large nail
 above her heart
 brush-hammered
 in

An [Annotated] Audit of Kahlo's Self-Portraits

 monkeys dogs
 parrots parakeets macaws
 her fawn
drape about her
 like the *rojo*
 of a Frida *rebozo*
aloof and still
her naked eyes woo
 mirror to canvas

the language of candor flushes
 her cheeks
no refined lady's fan
 no brash boa
 in these tableaus
 of roots tendrils nerves
hands clutch
 a cigarette here
 scissors there

dream-objects circle a floating bed—
 a suspended fetus
the bowl of pelvis
 a cryptic snail
 bruise-hued orchids
instruments
 for dilation and curettage

Diego/*diablo* her obsession—
 a medallion of his face
 planted
on her forehead
 above the forest

 of her brows
 wounded devotion

butterflies scarlet flowers of the prickly
 pear swell
 in her braided hair
bracelets circle unscarred wristbones
 strings of bead-stones
 and swinging
from a lace of twigs at her throat
 a pendant
 of dead hummingbird

 studies in anatomy
the tools of the surgeon-artist appear—
 for the painter's palette
 a heart
 stands in

 she is not Christ's bride

White on Canvas

—after Ruth Stone

A white bedsheet, whiter
soaked with blood, white pelvic
bone crushed.

White lace-trimmed
skirts, white toilet seat,
lid back, white lace gloves.

Schoolgirl uniform
blouse, one human arm
projecting from sleeve.

Broken conch shell,
white, white
skyscraper erupting from
volcano.

A sugar skull,
pale white moon. White
magnolias.

White rind of watermelon
and orange, tight white lace ruff
about the face.

White
lace umbrella against
a cerulean sky.

Still life
of halved papaya, bleached
splayed and seedless.

I Confess I Am Two

—a poem using titles of Kahlo's paintings

in the dream
my dream, I lie in bed—
bunked above me, a skeleton
 clutches
lavender blooms

me and my doll
a naked white-skinned baby
 propped up
 on the bed
we are such stiff witnesses

my scared scarred face
 hurdles
through a clearing
 on the head
of the wounded deer

I bleed in remembrance
 of the open wound
my spine:
 the broken column
my torso trussed

but my roots
 twine
the earth—
 living nature
 tree of hope keep firm

I am two women
 two Fridas
I am what the water gave me

Frida Sets Aside
Reds and Greens and Blues

—Two Nudes in the Forest, *1939*

Two nudes idle in a terrain of brown—
so rare this hushed palette.

Warm bodies fluent in skin hieroglyphics.
Only the sky storms gray.

A monkey unsleeps among timbers.
Frida's faithful pet, or symbol of sin.

Fingers rest on velvet hair, her cheek
in a lap which consoles—

Frida's lover, or the self she longs to love.
Dark eyes fleck these nameless faces

in this brown-bramble sanctuary,
the sepia earth—sweet.

Aubade with Attention to Rib Cage

—with first line by Molly McCully Brown

I make an outside world from the space
 beneath my ribs

 where Frida's moved in.

It's a comfort to have her there
pillowed down—
 the throb of her
 undulating
 like the surf I crave.
I have no ocean spit
 to paste me together.

I've tried every poultice.

Come morning,
 shut-eyed, my skeleton
 papered
 in thinning skin sprawls
on blue linens,
 muscle
 primed to clench
 the pain
 keep it buried
in the bureau drawer of my chest.

When day breaks,
 it's not
with a clamor of seabirds.

It is Frida I hear,
 Frida
 who comes to me—
 sé gentil
 a balm
beneath my ribs.

Dear Frida

—found lines from Kahlo's diary

You, I tell you, your eyeball is
 glass—sea magic.
 You are here,
she who wears the color.

You intangible you are
 a universe
 you.

You breathe through
 glass.

Querida Frida

—Líneas encontradas en el diario de Frida Kahlo

Tú, respiras a través
 del espejo.

Tú, te digo, tu globo de ojo es|
 de vidrio — magia del mar.
 Ella estás aquí,
ella, que lleva el color.

Tú intangible, eres
 un universo
 tu.

Tú respiras a través
 del espejo.

Things Riven and Relentless and Real

She's broken my friend
says of me. It's what she tells others
so I don't have to explain.
To anyone.

Broken. Like a horse
led first by the halter, then
habituated
to bit, bridle, weight?
Broken so it will follow?

Or *defective*
like the cheap plastic bird feeder
with yellow perches
that fail even the finches?

Shattered? Like ochre
glass in the country
church window
where empty pews
wait inside, the altar cloth
untouched?

No. It's wires crossed.

A glitch,
a glut of chemicals
sending messages
from the pain place
to the spinal cord
to the brain.

Pain that doesn't ebb.

Not hangnail
or splinter. Or
a stubbed toe
that hurts like hell
for a time. Not like
a broken wrist, ankle,
not the broken bone
pain that mends.

Not *tamed.*
Not *defective, shattered,
collapsed.* No.

Broken.

A Mind on Pain

a fistful of amber
 buffets the window—
 the blind's slats
 splinter
 light into golden bars

still morning

 lie down just a minute breathe

lost minutes like fence pickets
 line up to be counted

 so swiftly
 it's raining again
 drizzling the pane

 so many
 doctors
with no answers

how much my head
 on the pillow
 hurts

 top of my head swollen
anterior fontanelle
 the soft spot
 on the baby's head

I need a lullaby
 did my mother sing

 Guardian angels
 God will send thee,
 All through the night...

if I hold my breath
 until night
 swaps shoes
 with day
if I hold my breath
 will the pain
 go away

You Wound Me

—The Two Fridas, *1939*

Here we sit, two cabbage roses. Have you forgotten that we are happier without ruffle and lace? How well our skirts hide the scars beneath. Our artery ribboned like an umbilical cord girdles us. Don't you see? You bleed, we do, while the sky argues with the clouds whether to be gray or white. No penance to be paid for lost children or false lovers. I whisper, *put down the scissors, Frida.* Put them down.

So Be It

—cento, lines by Ruth Stone

Fear lies
 upon the body
split
between the perfume
 of sex and pain.

In the wing-language of April,
 love lies asleep
over ravenous fields—
 a botanist's mirage
 of wildflowers.

My love lies
 folded into himself—
 the sadness
 of his quiet.

It is my body that knows
 my body—
 this sex
 and pain
rushes behind—
 the body bends
 to accommodate it.

After a while it becomes
 my old friend.

In the Warehouse of My Spine

Not even a quake or a starling
could crack a coil
of rubber bands.
Solid in the hand with some give.
Unless the body is that ball—
a fist of tight.

Mornings I lie in bed long
to dispel the tension within.
My body fetal—
I chide myself
to uncoil, imagine
the body-snap of bands
layer upon layer letting go,
slackening the pain
in the warehouse of my spine.

The crux of it.
I'm left
with a troubled core—
as safe as I'm ever going to be
in the womb
of the world.

Titch by Titch

—*for Deb Beyer*

Scoot over just a titch, she says—
eyeing the space on her table.
Titch? I question.
I have a quirky affection for words.

It's a word. A small amount.

It is a word! She was right—
my physical therapist
with hands and eyes that seem to hear
what rattles wrong in the body.

It's been months, no years now.
And still there's no end to her repertoire.
Each visit, first I walk,
and she observes my movement.
We talk about my body's pain and performance—
like an engine diagnostic.
And her repairs are rarely the same.

In between I text with questions.
Always a response about what to try.
My tush is on fire—
Place one hand on the base of the skull.
The other hand on the chest spanning
each side of the sternum.
Gently rock the chest hand
side to side (a small amount).

I do. And it's better.
Titch by titch.

The ankle's tight, doesn't flex—
If you have Kinesio tape,
tape back the distal lateral ankle bone

*and try walking. Then try taping the talar dome,
the tape pulled open maximally.
Like a Band-Aid.*

Her knowledge. Wisdom—a Band-Aid.
Salve for the wounded. The hurting.

I've spent years looking for fixers.
Self-fixing. Learning names of the anatomy
because I needed to. Tunnel-visioned
in desperation.

*Go easy along the line from the ischial
tuberosity to the sacrum.
That's the route of the sacrotuberous ligament.*

Titch by titch.

At times I fret the fixers will give up.
That she will. That I will.

*I think you need to get your diaphragm
on board—breathing is a must.*

The pain subsides. She gives me tools.
Body-mechanic tools.

Yoga Nidra to muffle the nerves, modify the cells.
NFP, neural fascial processing—
a tune-up. Blueprints for redesigning
the body without new parts—

all repairs I can do
to bring back the body's humming
when the pain ratchets up.

Titch by titch.

I need to clone you, I say.
No cloning, she texts,
adding the scared paled-blue-head
screaming-in-fear emoji.

And once when I'm afraid, I write—
I hope you don't ever give up on me.

Never giving up!

When her body stamps its foot

When a warped leg and gnarled spine hide under cotton

When nerves ricochet in waves from traps to glutes to occiput

When an enameled mask is the face she bares

When her head swivels like a praying mantis but her body cannot move

When reckless sex ignites the dragon of pain

When her gullet swallows a kerosene-grief

When paint on canvas will not muzzle her reality

When grit and gnash unswallow hope

When her body broken persists in oil

When her chin's tipped up to the moonstone sky

For the Cessation of Cutting

—Self-Portrait with Cropped Hair, *1940*

The thing is, Frida, your hair's a bed
of seaweed at your feet. You, again
with the scissors. Diego's clothing, bloating
your figure, the fabric of his steel-gray suit

falling in folds from what's left of you
after the cutting. You have sheared
the Frida of you. Let me take inventory.
Hanging from sleeves, hands, waxen

and doll-like, comatose and unfleshed.
Your hair, an ill-fitting skullcap
on your head above the long ellipsis
of eyebrows. No longer ornament, crown,

or distraction. I dive into your eyes
piercing like points of the scissors' blades.
And yet, delicate earrings drip from your lobes.
Are you renouncing love, lovers,

your lover's obsession with beauty?
You must quiet the lyrics that scroll
above your head—*Mira que si te quise,
fue por el pelo, ahora que estás pelona,*

ya no te quiero. Who needs someone
who loves you only for your hair.
Promise. Cut away nothing—
but wound-maker and wound.

BLOOD-LETTING

—The Wounded Table, *1940*

Not saints, you and I,
 but may I please,
 please be seated
 with you at the wounded table.
Let us exact
from each other an oath
 to loosen
 the pull of
 men's honeyed tongues
the sharp-boned
 clench of hands—
loss and pain vined
 about our necks.

It is hard to weep
 when living
has made us
 strong.

Burying the Heat

I've woken from this dream before—
each time I'm behind the wheel, needing
to merge onto a busy street, but my eyes
are closed, as if stitched shut, and it's fruitless—
the effort to open them, to see where
I am going, who I will smash or what I will destroy.
I know when I wake that the me
in the dream isn't seeing or is refusing to,
not wanting to admit that I'm more the lead
in *The French Lieutenant's Woman*
full of forbidden longings, trapped
on the pages of a Victorian tale.

All the while I pretend otherwise—
pluck daffodils and bake bunny-shaped cookies
with red hots for eyes until I remember
the me of she that slipped lavender sachet
in with the thigh-high black stockings
and the pink garter belt. I'm stuck
in the dream, eyelids sealed,
heartstrings tied to someone never fully mine, taking
him when I can have him, pretending
it's joy, knowing nothing can keep
the lingerie or me from fraying with age.
For now that bottom dresser drawer stays shut.

Dear Frail Dark

I fold
 myself into the lap
 of he who would be
 my Lord of Love
 I welcome
the *la* and *fa* of larksong
 the *aah* of surprise
 come to salvage me
 from him from myself
 let the warbles oil the air
 for flight

 I'm pinioned by need
 my own his
 lying heavy
on every dahlia'ed wisp of hair I pin up
 I should leave him
 how it disturbs me
 our futile love un-haloed
I could be half again as much
 and still not be
 enough

the greedy fork he lifts to his lips
 this love-hoarder
 eating me alive

Frida Kahlo Speaks to Ada Limón about Bright Dead Things

—after Ada Limón

I am a keeper of lists. An apprentice of all the ways to be silent. Fused to Diego sleeve-to-sleeve, his colossus of a body in overalls, my heart straddles the border between home, my home, my Mexican barrio, and Diego's America choked with smokestacks and dollars. I learned muted silence from one, two, twenty and more surgical incisions. Stitched-up and struck numb in the airless sheets of my bed, I await resurrection in a bounty of silence—mad silence and the broken harness of marriage silence and the silence of painted coconuts weeping and then the silence that bellows in my ears from tangled infidelity and bottomless pain and lost-hope babies and surrogate lovers until it dims all the bright dead things. I listen for a hum in the mercy of silence, count all the silent places where I grieve the shredding of my breath.

I want to be inside your darkest everything

because I
want what's holy and what's unholy without asking absolution, want
to wake in night's thin vellum to moth wings incandescent in the lamplight, to
be lust-flushed in the abandon of whisker and wet, to be unveiled, to be
willing, hungering, breath gulped and swallowed inside
the darkness of swollen lung and quivering belly and mortality and your
redemption, mine, like unmapped constellations in the darkest
darkest heavens because I'm riveted to you, spellbound by your darkest
everything.

The Pinch of Love

Diego comes to me
brandishing
 his manhood. My sky—
 periwinkle
 mango, and the earth,
mole and leaf green until

he wounds me.
 Unfaithful beast.
My heart wants
 to shutter him out
 to disremember
 his voluptuous lips pressing
mouths of his lovers
 as easily
as he signs his murals with a kiss.

 Unmoored.
I'm excised
 like pomegranate seeds
 parted too soon
from the pulp. The marrow—
 ours,
stained, unripe. Rejected

I weep. I rage. I curse.
He is my opiate
 as surely as tequila's
glimmer slashes my pain.

Without him, I am
 madre de nada.

In the Absence Of

Cobalt-blue walls parrot the night sky.
 I paint microcosms not galaxies.
 My body shrinks
 with the voided fruit of my womb.
I am barren canvas. Complete me.
 You and I,
we must eavesdrop
 on our mouths that shape
the words our ears
 will not hear when we know
 love's wrong.
Seeds spill from the bowl of a melon.
My mantra: *I am not a shadow.*
 I am not.
If there is a lapse of pain,
 how will I know my lungs inflate?
My warped spine's plastered to an iron will.
When I tap my collarbone, I hear
 my lost child weep.
What if I look in the mirror again and no one is there?
 I am not…
Who needs a man to sew up my name—
 I have wailed: *Diego. Diego.*
 My love, my love. Diablo.
 And tomorrow, my love not.
 But I will bleed night-sky-blue for you.
Sorrow comes
 in spoons and buckets.
I feed myself the milk of my unclaimed breasts.

I Speak to Frida of More than Daisies

I am rapt. Caught
 in your perfume.
 Why?

So familiar.
Your pain is a gash
 I can fathom—
how you number
 your heart-pings
 recite the refrain
 ceaseless—
 Loves me Loves me not
and watch
 plucked petals
 pool at your feet.

Your paintbrush stings, slashes.

I plumb your eyes on canvas—
 glimpse
 the longing
 mirrored there
 iris to iris.

Permit me to inhale
 your essence
 to dispel the bitter
metal on my tongue
 when I press you
 like a violet
 to my cheek.

Boiling It Down to Kahlo

 This woman?
 she
 lived in obscurity
 Her work was known, but not like it's
 known now
 beautiful
 body of work
 spans galleries and galleries
 no digital machine
 to propel— just the work
a big gigantic spirit

 Like many women Kahlo is
 a beacon. despite
 despite

 a model for how
to live a sea
 of tears of ecstasy.
 The Phoenix

In Frida's Diary, Everywhere the Eye

— *"Of my face, I like the eyebrows and eyes." Frida Kahlo*

An eye replaced by lips, a floating black and olive
oversized eye, black eye-blobs on a dancing skirted skeleton,

an eye on a thigh, tattooed on foreheads, blackened on
a head dangling upside down, pupils in blued whites of eyes

in a moon-like face, glassy puppy-dog eyes, heavy-browed
eyes, bleary, drawn on big-bellied vessels holding

woman-faced flowers, eyes pencilled on Egyptian birds
and giant insects and maybe a llama. Wide angel eyes.

Diego in the lap of charcoaled slit-eyed Frida in the lap
of Mexico as woman in the lap of a Buddha-like universe.

Giant eyes dripping sperm-like tears from an angular
urn-like face. Eyes in the heart of a bloom.

Broken-winged uni-browed Frida, eyes deep dots.
You too know that all my eyes see.

Everywhere the I.

For Daughter, Unborn

I wanted you to soak
in the aroma
of frangipani before
you felt
the rose's prick.

I wanted to quell
your fussing
as I night-owl,
listening for the shudder
of your need, to trace
the filigree of purple veins
in your forehead, inhale
the sour milk
of your breath and say
ohhh, this is good.

I wanted to coo with you
at the mourning
doves beneath the window
jabbing at the cracked
corn we scattered,
wanted to open
you to cobalt blue
and seaweed and crocus
in snow.

I wanted you to know
love for your dark eyes
mirrored in mine
before you're wooed
into the love-vortex
of another.

I wanted to hold you,
our hunger fed, after you
ripened in my pelvis—
I, fruitless,
after pain came. I wanted

to never have to whisper—
no formula
can measure
the volume
of an empty womb.

DESPERATE BEAUTY

—"I paint flowers so they will not die." Frida Kahlo

We are watchers, Frida,
aching but obedient to light,

resurrected by shocks of color.
Mornings you pluck

bougainvillea or pearly
gardenias, plait them in your hair

above your brow. I shadow
the fire of spring poppies

and the profusion of lilacs
and pink hydrangea.

With the organ pipe cactus,
you spike a sage-green fence

on the borders of *La Casa Azul*
tuned to the rhythms of sun

and rain—its lavender-white
flowers tint while you sleep.

Our love-eyes like greedy
tongues lick the rare-red

of wild angel trumpets.
We are *aficionados*. Pregnant

with joy in the garden's cosmos.
We pursue hues like lovers'

lips, stalk columns of yellow
calla lilies, praise the spell

of honey-petalled sunflowers
and the lobes of violet irises.

We thrive on iridescence—
our eyes attuned to its blessing.

Watchers. We bend near
in reverence to the bloom—

all pain humbled
for a time by beauty.

If I could lunch with Frida, I'd tell her why

I've turned my gaze to her body
punctured, crooked
like a young cypress
bent to the spoils of wind—
willing her limbs to swallow
what comes.

Our bodies, hers and mine,
have an appetite for pain.

What is there to do when
betrayal wears pants—or skirts.
In the glow of a cigarette's burn,
she tosses ash. Swears.
Withdraws. I bottle up.
Fish for the solace of sea.

We scrabble about for remedies.
Frantic. Feed an obsession for answers.
Does she catalog hope
the way I do—
by the timbre of a doctor's voice?
by the list of doctors yet unseen,
the treatments yet untried?

I window her eyes—
will myself
to be fierce like Frida.

Hunger

They won't last long—
 these two-dollar February daffodils.
Buds tight at first,
 then swift to bloom.

I'm not ashamed of my reaching—
 always combing
 for light and luster.

I need these fistfuls of beauty to survive.

 In the in-betweens
I teach myself to breathe
 mouth these words—
Allow the wisdom of the body
 to release what it no longer needs.
 Give it to the sky to hold.

And then with a two-fisted reach, I gather
 what's offered
 fingers snagging
 all they can hold.

The sky, the horizon a double-sweet
 trifle of color
 dawn and dusk.

The lark. The larksong.

My eyes rivet on the pond's
circling koi splotchy
 orange and black
 white and red
bodies like loaves—
 not knowing
 they are food
for the ravenous.

Everything Moves in Tune with What the Belly Contains

—Without Hope, *1945*

Slight in your oak-framed confinement
your naked body presses the sheets—
your coverlet
swims in moon-pie shaped
microbes and cells.

The artless easel drools
fishheads, a plucked chicken, the leg end
of a turkey, stringed sausages that hang
with eviscerated entrails—
funneling food-fuel to your lips,
putting living on hold.

How might I prune back
the evidence of your suffering?

Only the sugar skull
sweetens the unbutchered meat
you swallow and regurgitate—
an ill-fated omen,
your name printed above the caverns for eyes.

This is not the rhapsody in the marriage bed
you long for.
Not a dreamy diaphanous starlit night.

I want to cup your tears, pour
them like bleach on this hope-defiled canvas,
remove the sun rimmed in red,
a blazing marigold.

Let me dim the proof of your wound—
leave only the soft moon to dimple your sky.

Muscling In

you elbow in
 claiming your dominion
gray-bearded Grief,
 hear ye! hear ye
 all is loss, all is losing

you've left your graffiti on the bone
 stamped a name on the tongue
a surge in the breast, a lament

there's no way to whitewash

a corpse flower, leaving
 us no space to blossom
above, the sky rejects blue

you swell and swell, your presence
 like water slapping
such an oily abundance—

slippery trespasser
 multiplying multiplying

The year of broth

she calls it. The year
 Frida shades a dark-green
winged figure on the back page
 of her diary, the year
of thin-souped sustenance,
 Demerol, cigarettes,
brandy and cognac, cocktails
 of narcotics mixed in vials
injected into soft
 yet-unspoiled flesh.
Diego—there and not.

On her desolate canvas,
 the final smudge—
gangrene and amputation.
 Doctors advise removing
the right leg at the knee.

After. She orders
 scarlet leather platform
boots spangled with gold,
 Chinese embroidery
and a bell affixed to the right one,
 a prosthetic wooden leg.
Why does it have to be ugly?
 In time. She prevails.
Revivial. One last *dance of joy.*

Renunciation

So many days and nights she lay in bed—
brittle and soured. Placed on a pool table, left

for dead after a streetcar hit the bus she rode.
Forced to lie in body casts she embellished

with monkeys and tigers, hammers and sickles, a fetus,
cord of the umbilicus—a skylight hole near her heart.

Constrained after miscarried babies, and before
each gurney rolled into the next surgery

and the next—no cure for a riven spine.
She would not be buried—recumbent,

rooted to coffin or earth. In death, body to ash.

Stack of What Made Kahlo Kahlo

—after Anne Carson

 Hunger. An insatiable
 appetite to be mended.

Her father who said that she is most like me. And he to Rivera,
 She's a devil.

Easy fabrication of her birthdate
 as 1910 to match the start
 of the Mexican Revolution.

 Take a lover who looks at you
 like maybe
 you are a bourbon biscuit (she said).

Monkeys. Mexican symbols of lust.

Monkeys in her self-portraits
 girdling her like armor.

 Again and again
 the merchant
 of truth.

 I drank to drown my sorrows,
 but the damned things
 learned how to
 swim
 (she said).

Labyrinthine.

Swapping identity:
 "Diego Rivera's wife"/
 "Frida Kahlo."

 Her painting, *The Frame*,
 purchased by the Louvre in 1939.

 Amputation of gangrenous foot.

Pies, para que los quiero, si tengo alas pa' volar?
 Feet, why do I want them
 if I have wings to fly? (she said)

 Morphine.

 I hope the exit is joyful and I hope never to return (she said).

I Design a Tattoo for Frida

I toy with the idea of tattoos—briefly.
I cannot invite pain. Pay for it.
But I muse.

I watch how they coil around the body—
back of ear, clavicle, wrist,
the slim of ankle,
just above the fall of jeans,
on the bulge of biceps.

What would Frida want?
A sugar skull. Flowers and that sweet bread
of the dead, *pan de muerto*. The scars
of a hundred stitches in vain.
The face of the *bebé*,
la hermosa cara, that never was.

Instead, I prescribe
creamy white petals of magnolia,
its bud, the shape of a heart,
opening on the soft edge
of her brown-skin breast—
intoxication with the scent inked in.
Now. And forever.

Diseño un Tatuaje para Frida

Jugueteé un rato con la idea de los tatuajes.
No puedo invitar al dolor. No lo pagaría.
Pero imagino.

Observo cómo se enlazan alrededor del cuerpo:
parte posterior de la oreja, clavícula,
muñeca, tobillo fino,
justo encima de la caída de los jeans,
en la protuberancia de los bíceps.

¿Qué quería Frida?
Una calaverita de azúcar. Flores
y pan de muerto. Las cicatrices
de cien puntadas inútiles.
El rostro del bebé,
la cara hermosa, que nunca fue.

En cambio, yo prescribo:
pétalos blancos y cremosos de magnolia,
su capullo, la forma de un corazón
en la apertura del borde suave
de su pecho de piel morena—
intoxicación con el aroma entintado.
Ahora. Y para siempre.

Postcard from *Casa Azul*, Coyoacán, Mexico

I'm here, outside Frida's door, steeped in oleander, and I cup in my hands these charms, these thin tin hopes for healing miracles—Milagros—an ear of corn, a fish for bounty, a horse. A sheep to mend a leg, to bring forth a calf or lamb. A house that needs a blessing, a car, a bus, a truck for safe travels. Body parts—kidneys, liver, spleen. Lungs to stave off collapse. Legs and arms, right and left tumble in the whole. Breasts to ward off cancer, a tooth, its root, a wish to end the ache. Lips to void the burn of words. And eyes for loved ones watching over. In her shade, dahlias and gardenias and I vibrate Frida.

Acknowledgments

I am deeply grateful to the editors of these journals for publishing many of the poems in this collection; some were subsequently slightly altered:

Beloit Poetry Journal, Clementine Unbound, Jet Fuel Review, Journal of Compressed Arts, Levitate, Nottingham Review, Open: A Journal of Arts and Letters, Origami Poems Project, Persimmon Tree, Pirene's Fountain, Postcard, Poems and Prose Magazine, Ran Off with the Star Bassoon, Red Hill Paint Journal, Stoneboat Literary Journal, Switchgrass Review, SWWIM, Sugar House Review, The Examined Life Journal.

An image of Cliff Harman's painting graces the cover of this book. I am incredibly thankful to have reconnected with him on social media. He was a student at the junior high where I taught more than twenty years ago. His vision of the words in this book feels perfect.

Gratitude to Karlen Torres, Virginia Bell, and Daniel Suárez for help with translations. The Frida lines in "Dear Frida" were taken from the English translation in *The Diary of Frida Kahlo,* (Alan Rotas, 1991) and were retranslated for the Spanish version of the poem.

Genuine appreciation to the Plumb Line Poets for endurance and encouragement, Patrice Claeys, reader and re-reader and proofer extraordinaire, and Ralph Hamilton for countless soundings and sage advice.

Cento sources, "In a parched time," Rachel Wetzsteon, Bianca Stone, Nancy Shih-Krodel, Jane Hirshfield, Andrew Hudgins, Alan Michael Parker, Kate Colby, Linda Pastan, Robert Haas, Elizabeth Arnold, Michael Bazzett, James Schuyler, Matthew Dickman, Anis Mojani, Michelle Ornat, Sophie Klahr

"Boiling It Down to Kahlo" —Erasure poem from a Facebook post by Krista Franklin, October 2018.

About the Author

A Midwest poet, photographer and teacher, **Gail Goepfert** is an associate editor at *RHINO Poetry*. She has four book publications—a nod to the natural world in photoverse, *in gratitude for days gone by* (2011), a chapbook, *A Mind on Pain* (2015), and two books, *Tapping Roots* (2018) and *Get Up Said the World* (2020). She has numerous print and web publications including *The Examined Life Journal*, *The Night Heron Barks*, *Sugar House Review*, and *Rogue Agent;* her Frida work has been featured on *Open: Journal of Arts and Letters*. Her first collaborative chapbook with Patrice Boyer Claeys, *This Hard Business of Living,* is coming out in 2021 from Seven Kitchens Press; together they published a photocento collection, *Honey from the Sun,* in 2020.

Glass Lyre Press

exceptional works to replenish the spirit

Glass Lyre Press is an independent literary publisher interested in technically accomplished, stylistically distinct, and original work. Glass Lyre seeks diverse writers that possess a dynamic aesthetic and an ability to emotionally and intellectually engage a wide audience of readers.

Glass Lyre's vision is to connect the world through language and art. We hope to expand the scope of poetry and short fiction for the general reader through exceptionally well-written books, which evoke emotion, provide insight, and resonate with the human spirit.

Poetry Collections
Poetry Chapbooks
Select Short & Flash Fiction
Anthologies

www.GlassLyrePress.com

www.ingramcontent.com/pod-product-compliance
Lightning Source LLC
LaVergne TN
LVHW090036080526
838202LV00046B/3844